To Derek & Dane,

Only thirty-five actual penguins were killed in the making of this book!

— Greg Stones
2015

GOODBYE, PENGUINS

Greg Stones

Greg Stones (signature)

Pine Ledge Publishing

For Brooke

Fifteen penguins went for a walk.

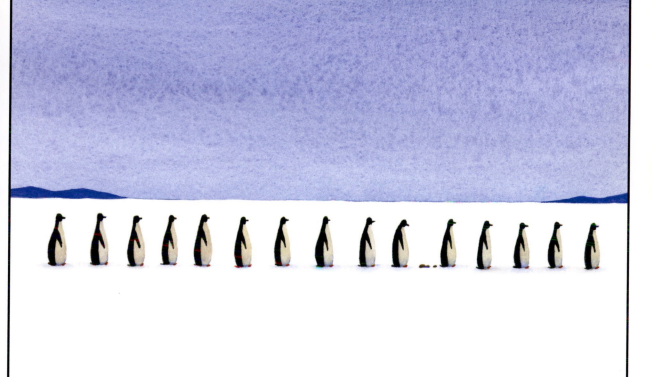

One penguin found a balloon.

One penguin was crushed by a safe.

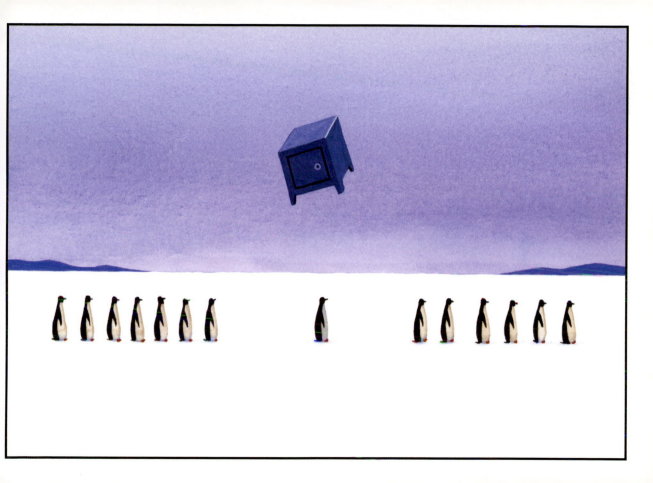

One penguin was abducted.

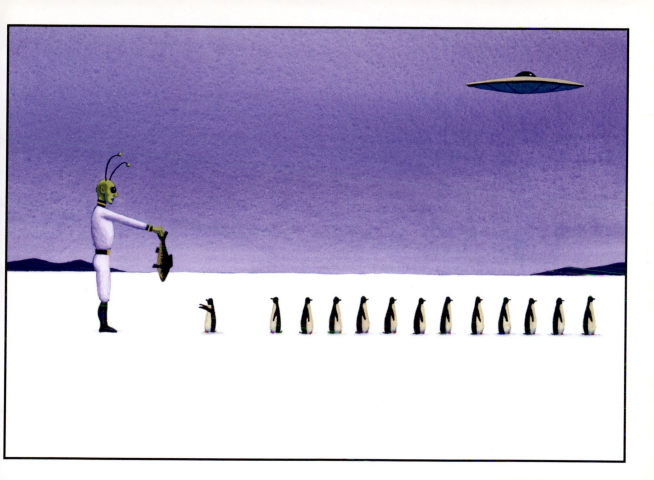

One penguin was shot out of a cannon.

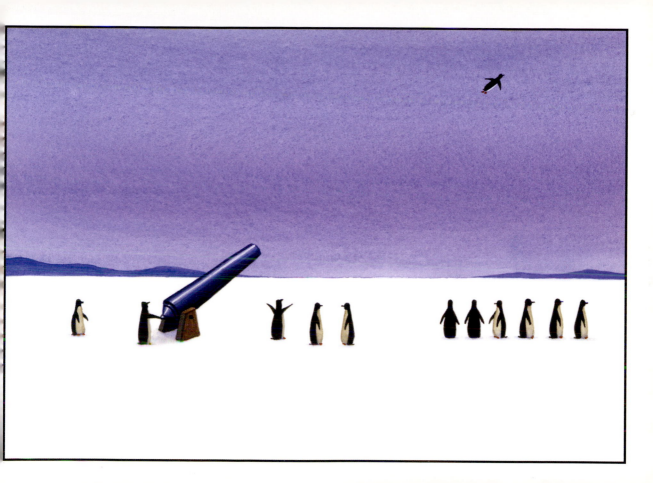

One penguin stumbled into a time machine.

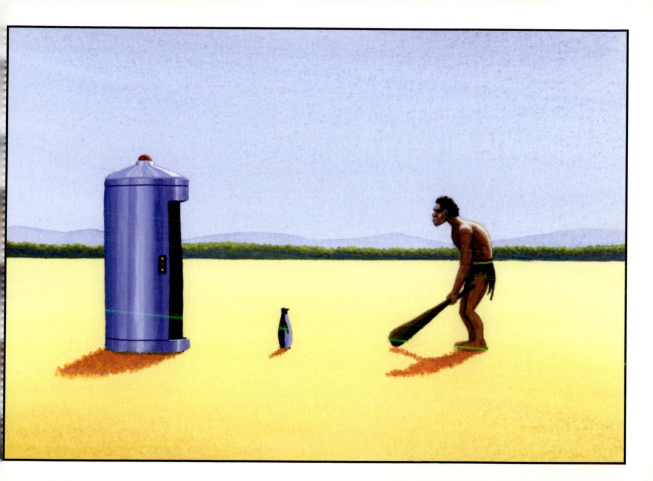

One penguin misjudged a zombie.

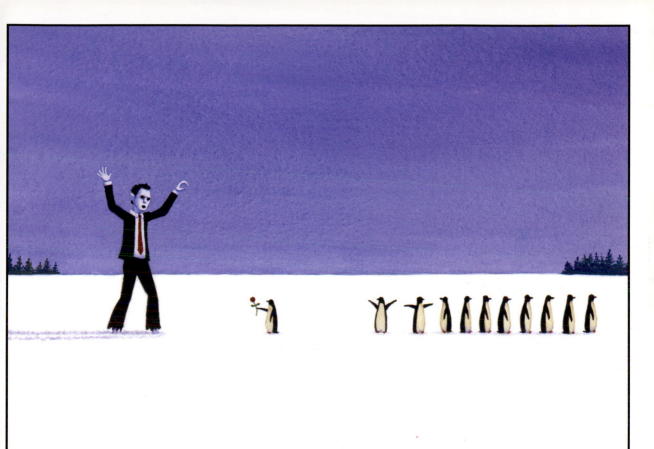

One penguin fell in love.

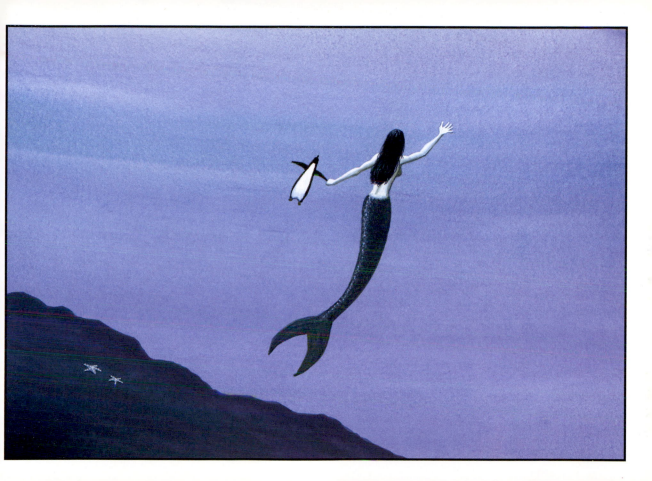

One penguin was eaten by a shark.

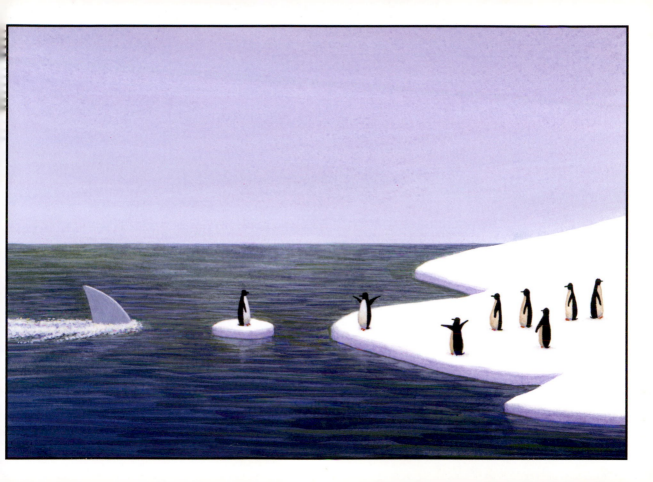

One penguin befriended Bigfoot.

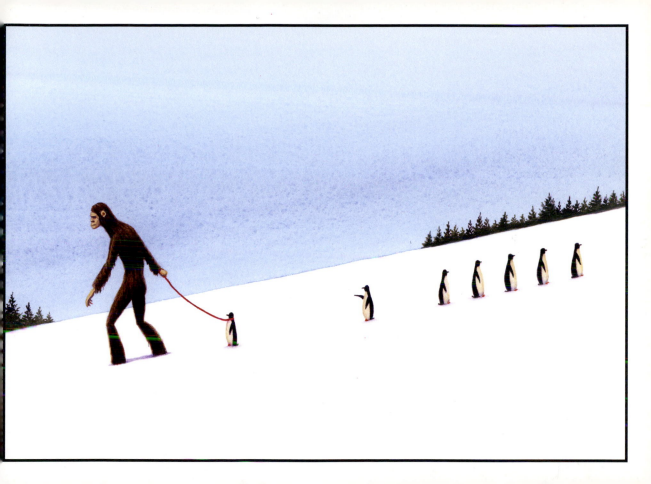

One penguin found a toboggan.

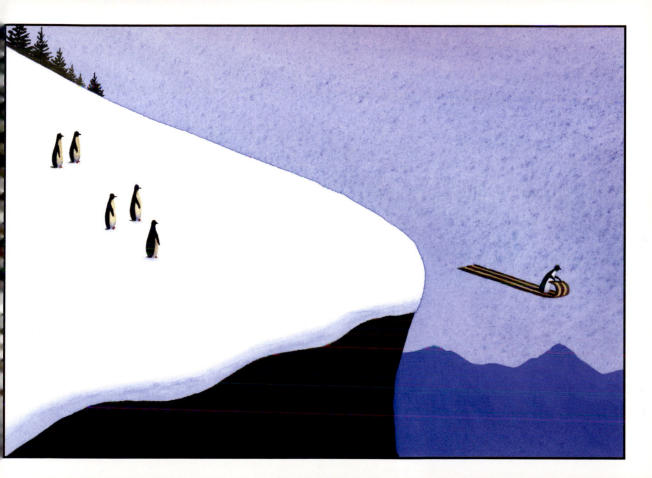

One penguin had a heart attack.

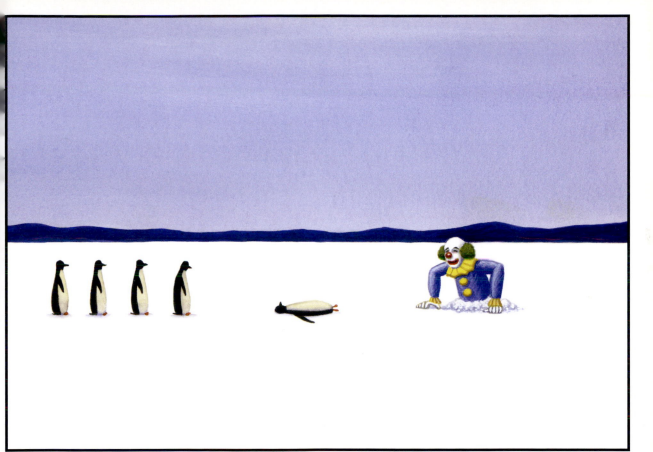

One penguin was flattened by a snowman.

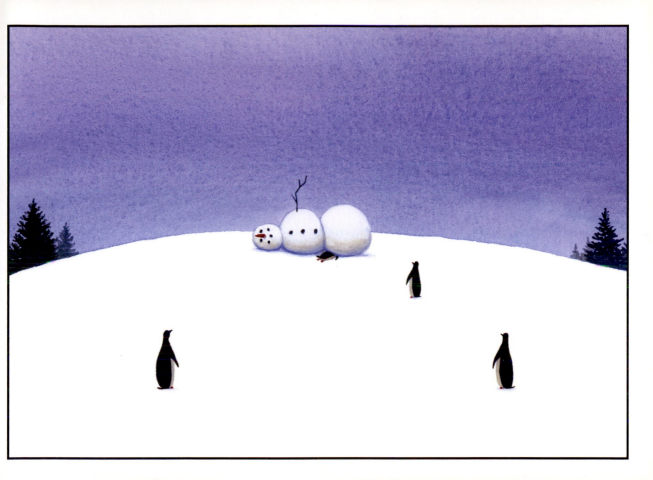

One penguin didn't see the squirrel.

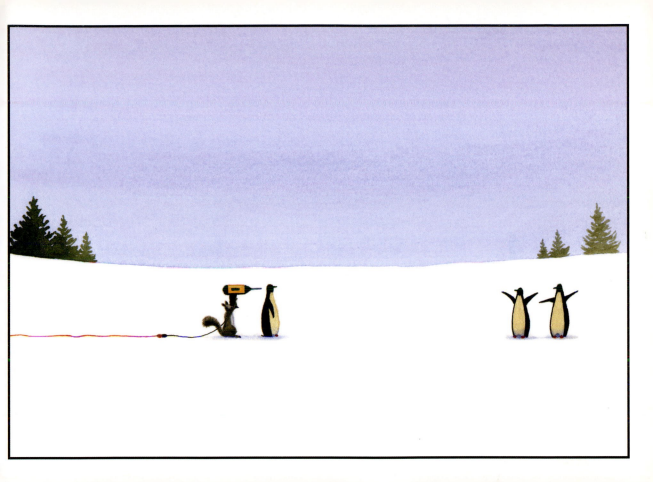

One penguin was hit by an arrow.

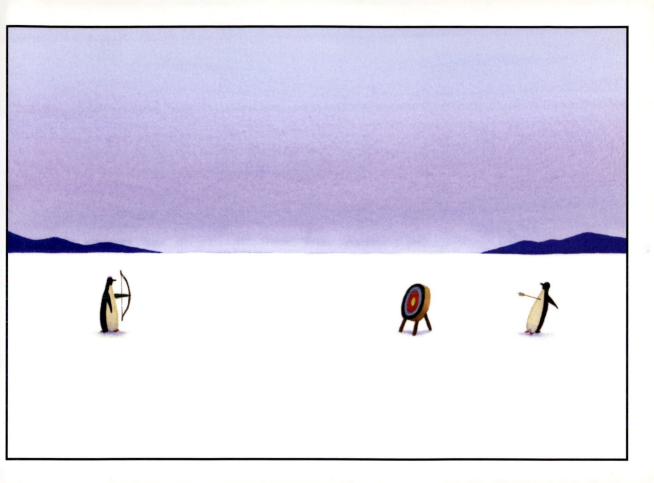

And the last penguin lived happily ever after

…for about five minutes.

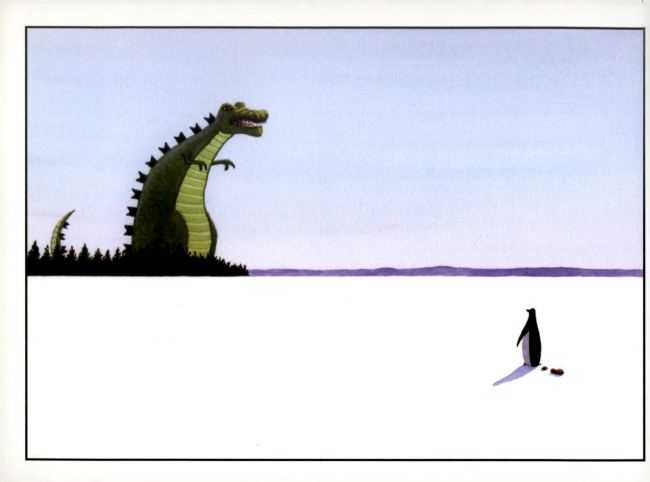

The End

More books by Greg Stones:

Zombies Hate Stuff
Penguins Hate Stuff
Zombies Have Issues
Sock Monkeys Have Issues

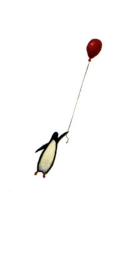